Michael's Drawing

Copyright © 2019 by Michael
All rights reserved.

Hi, It's Me, Michael. I like to play Lego and The Battle Cats. I want to be friends with everyone

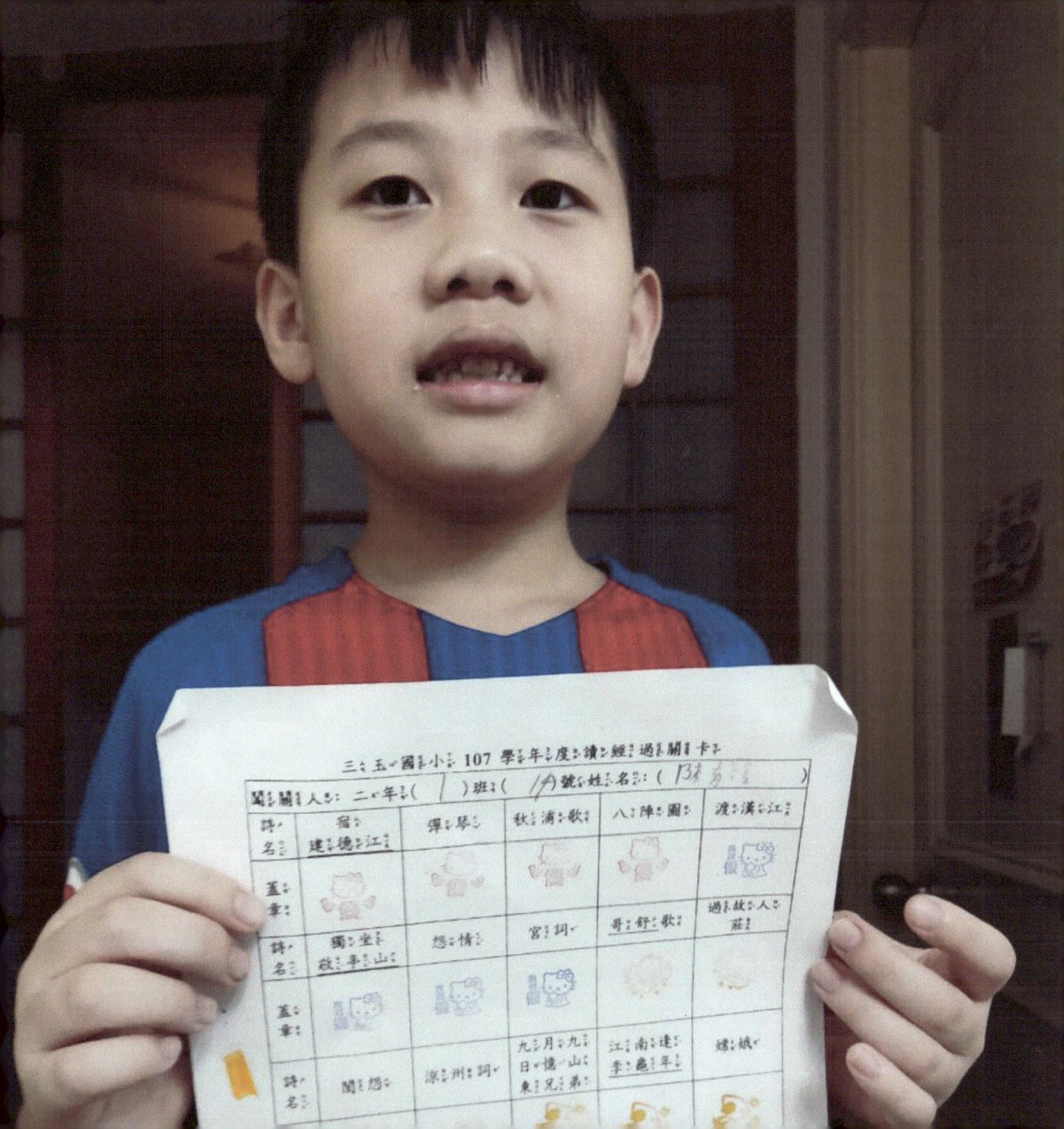

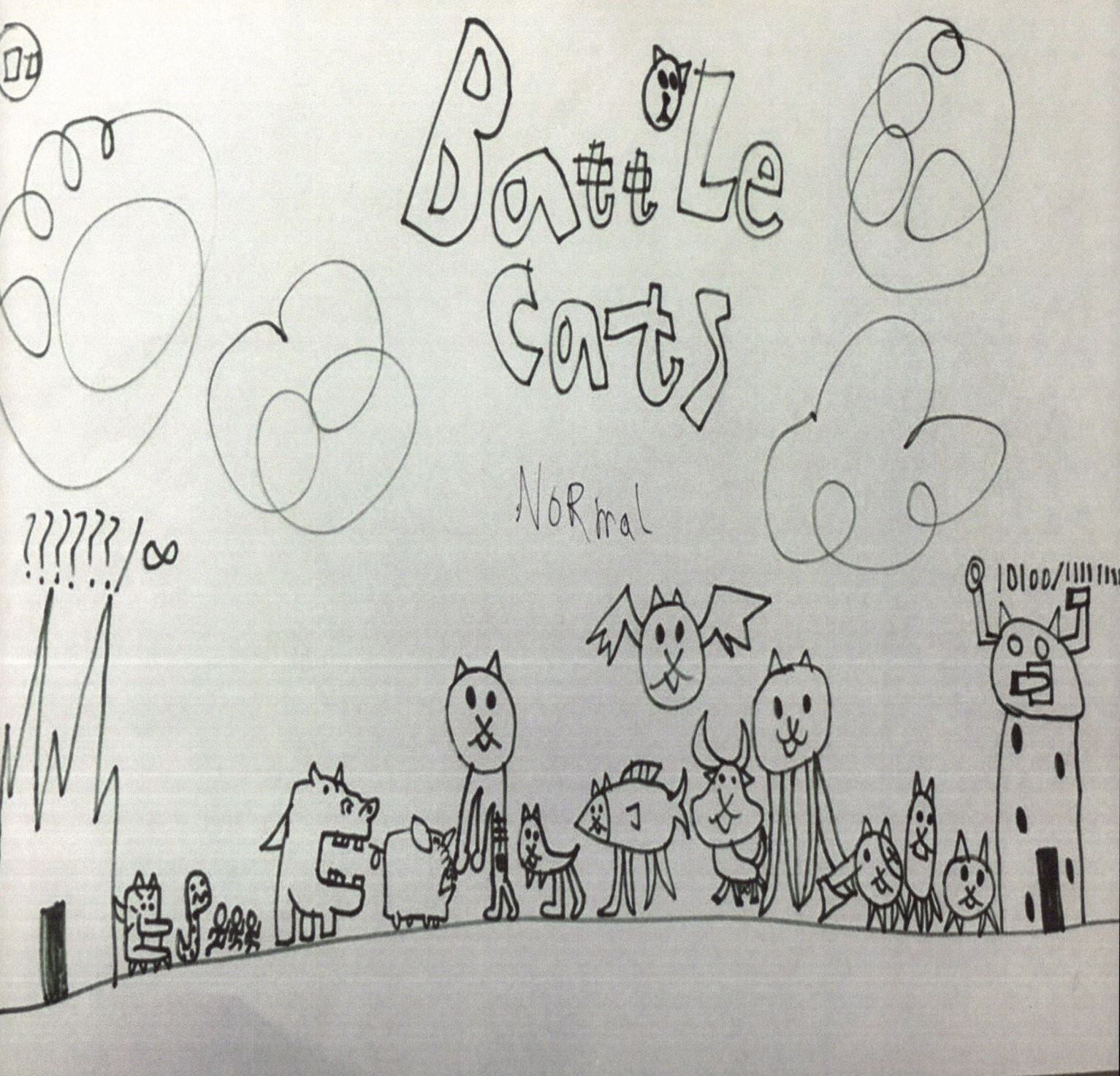

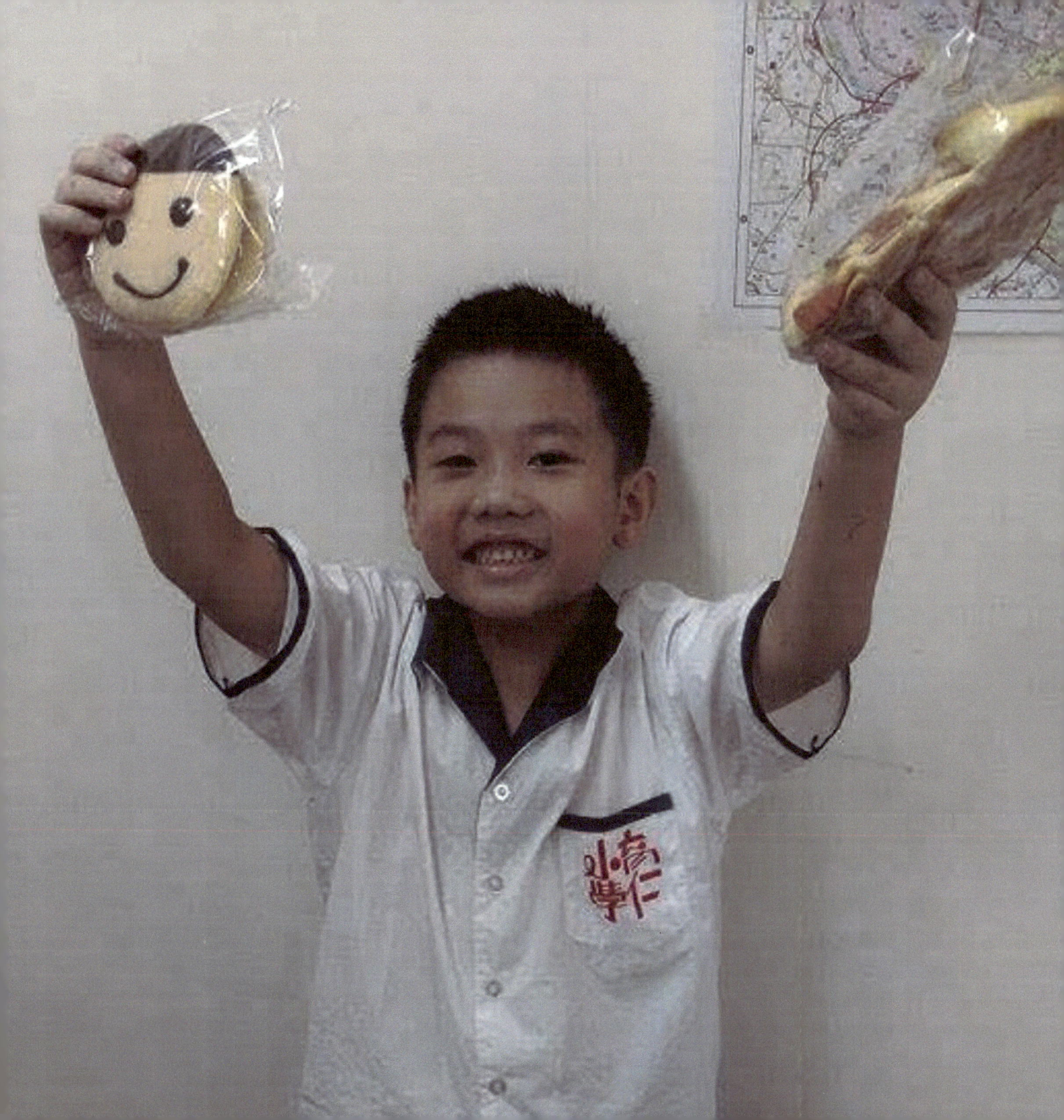

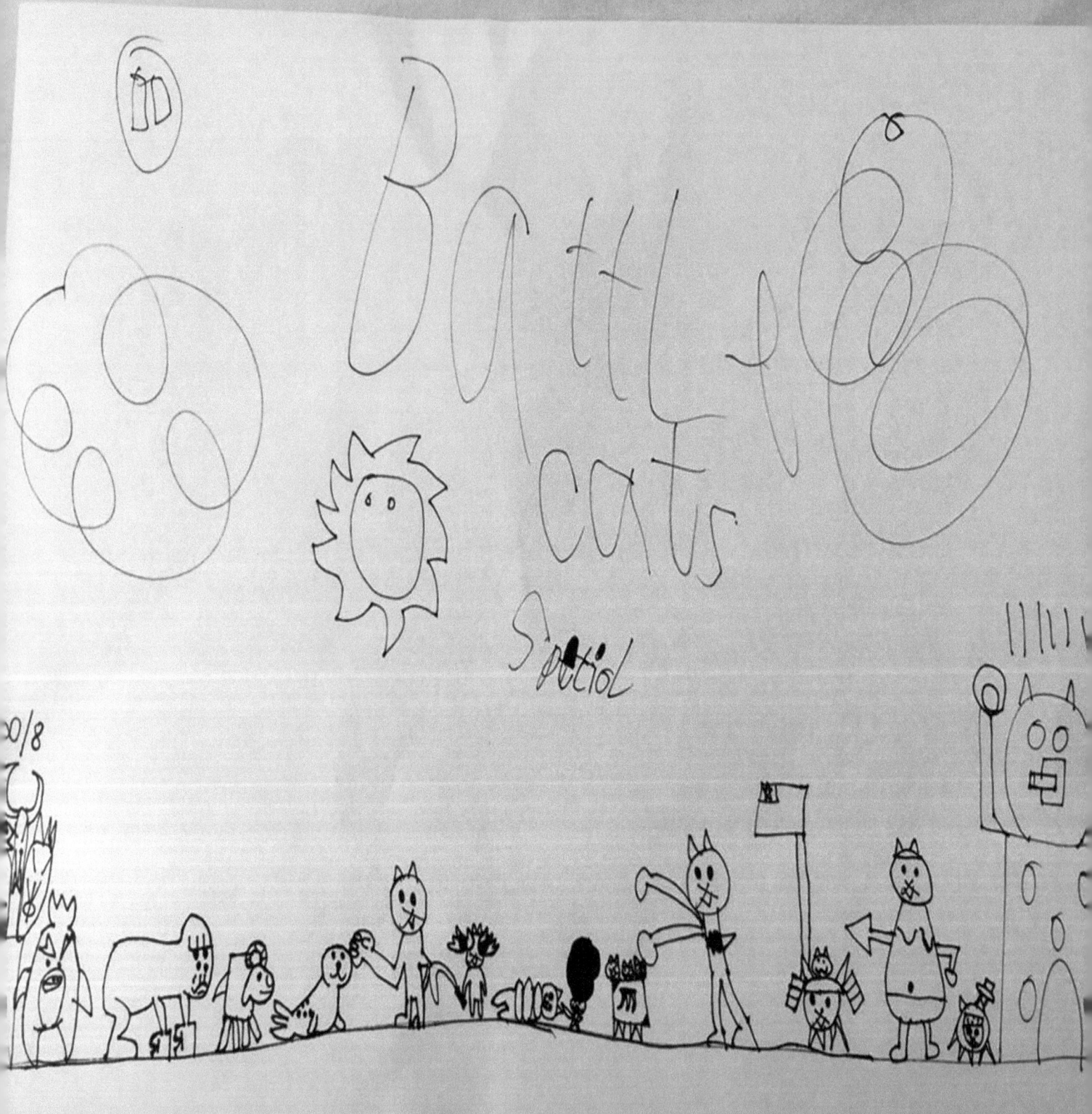

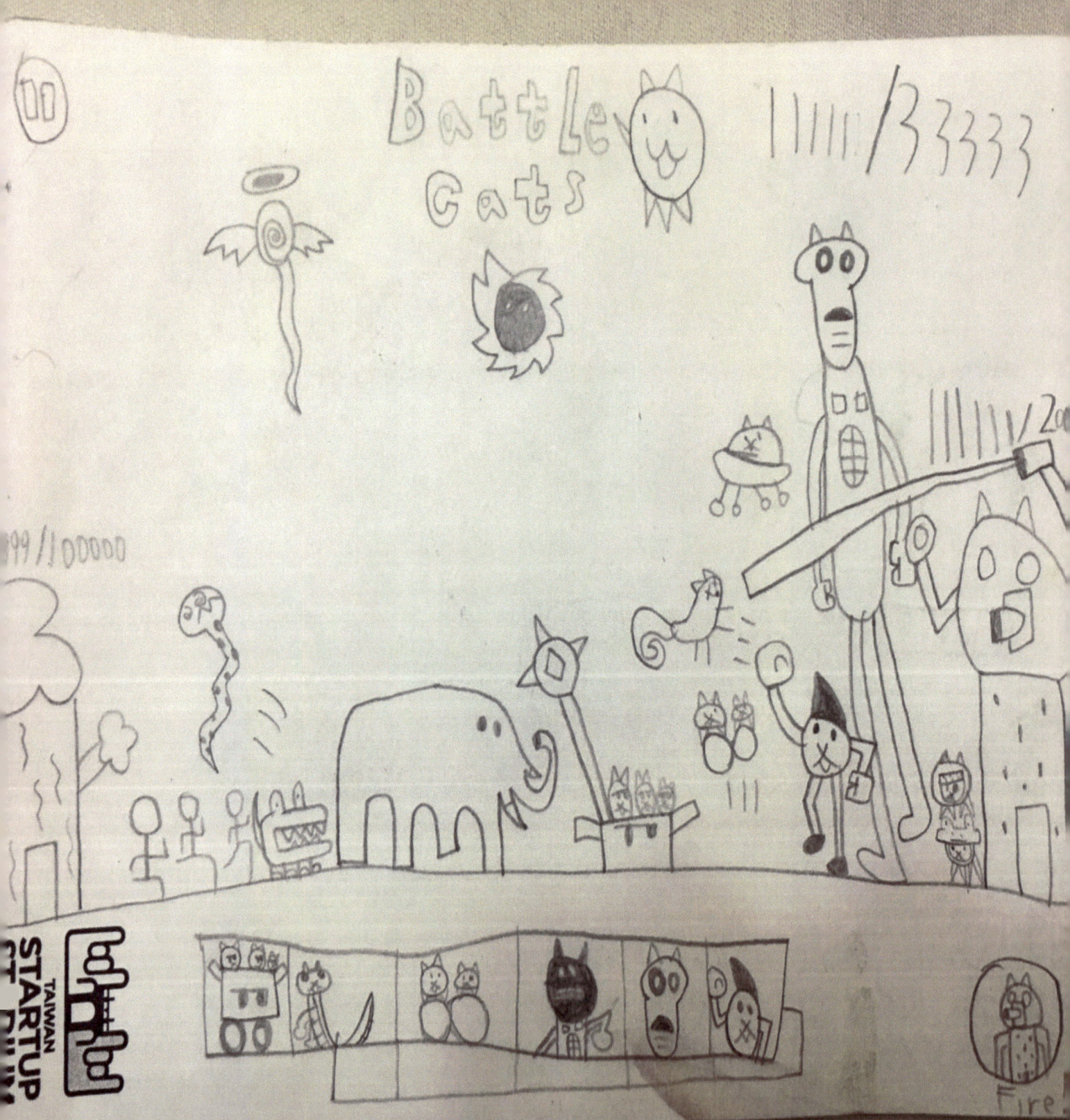

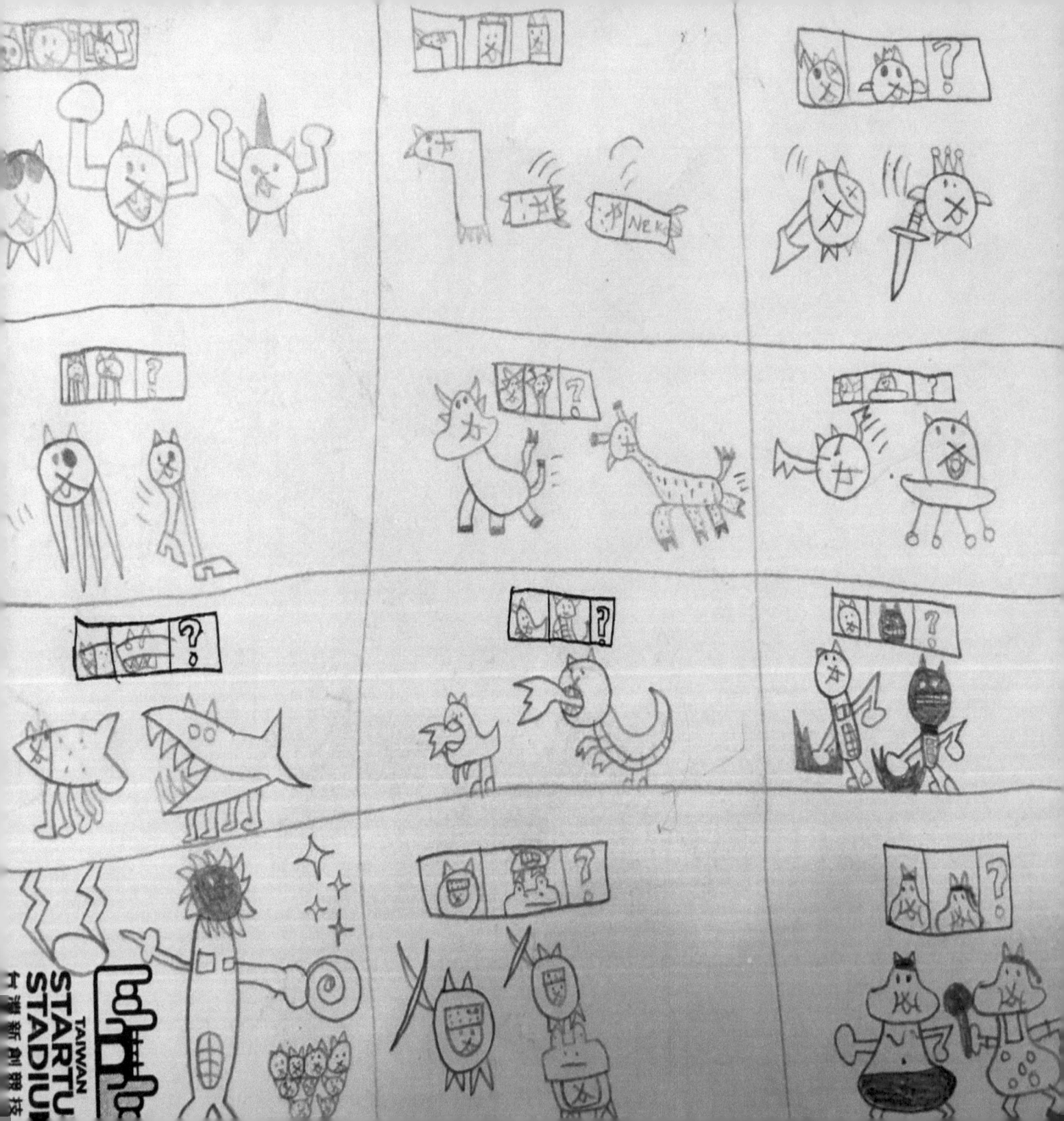

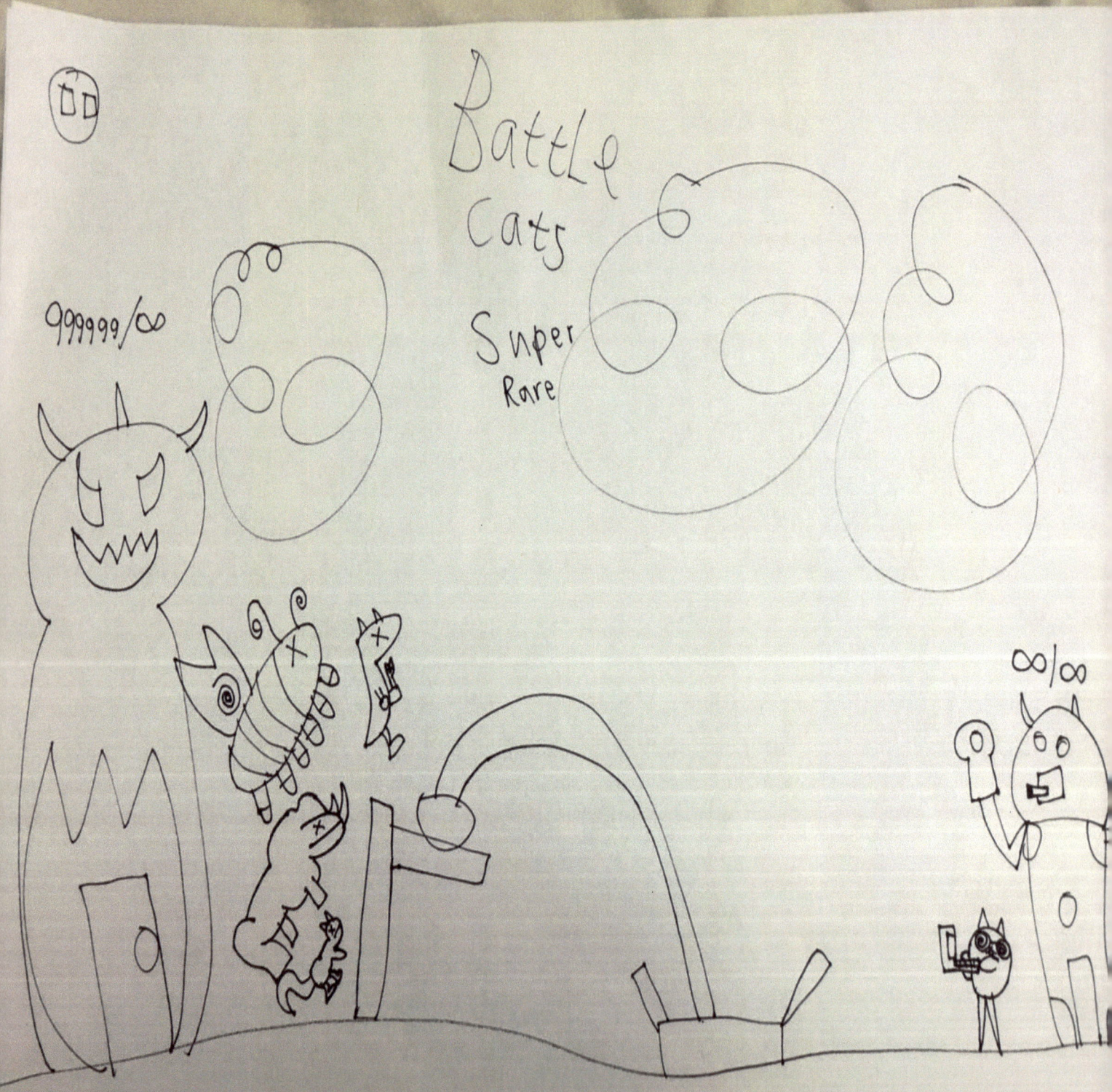

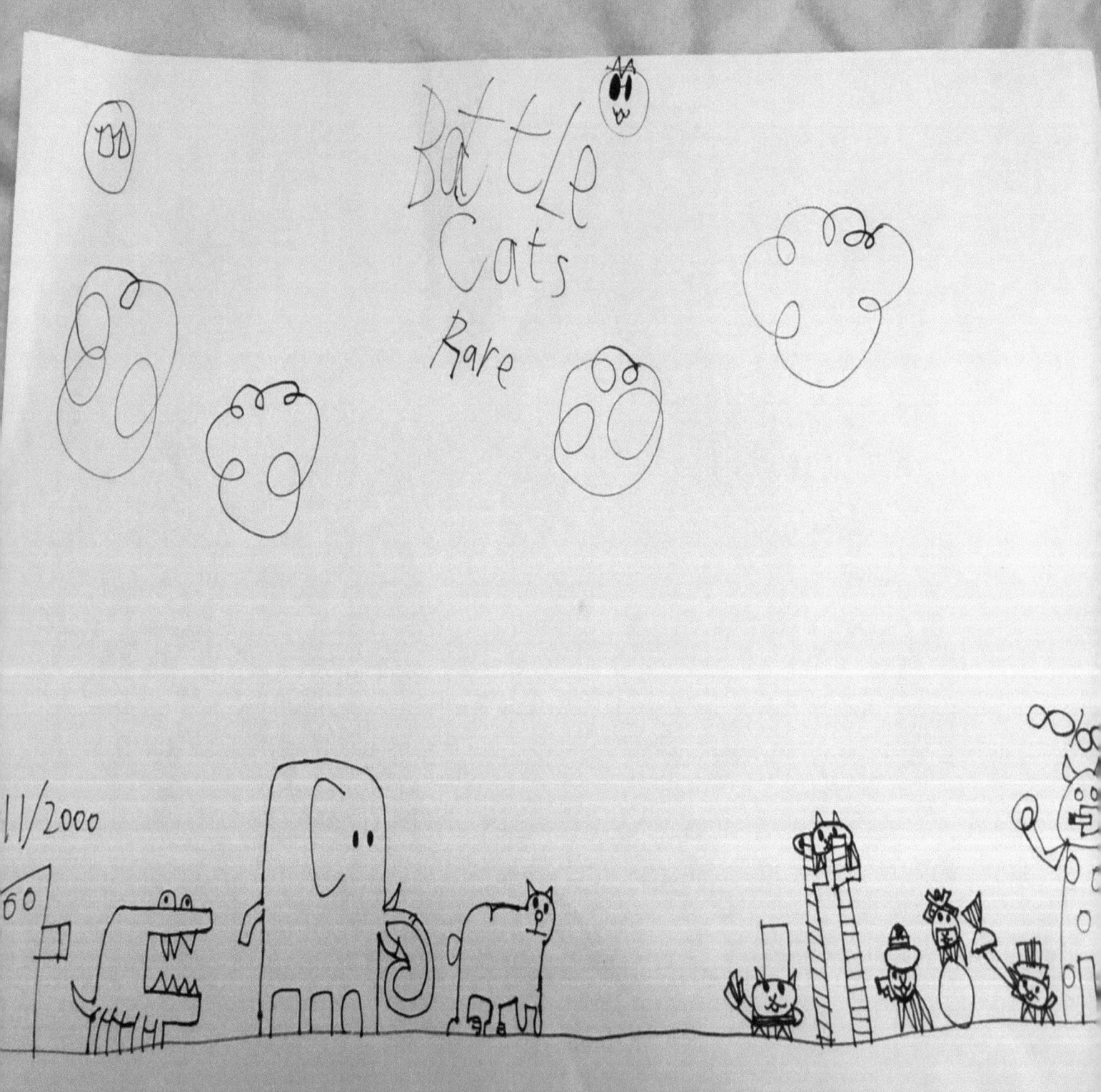

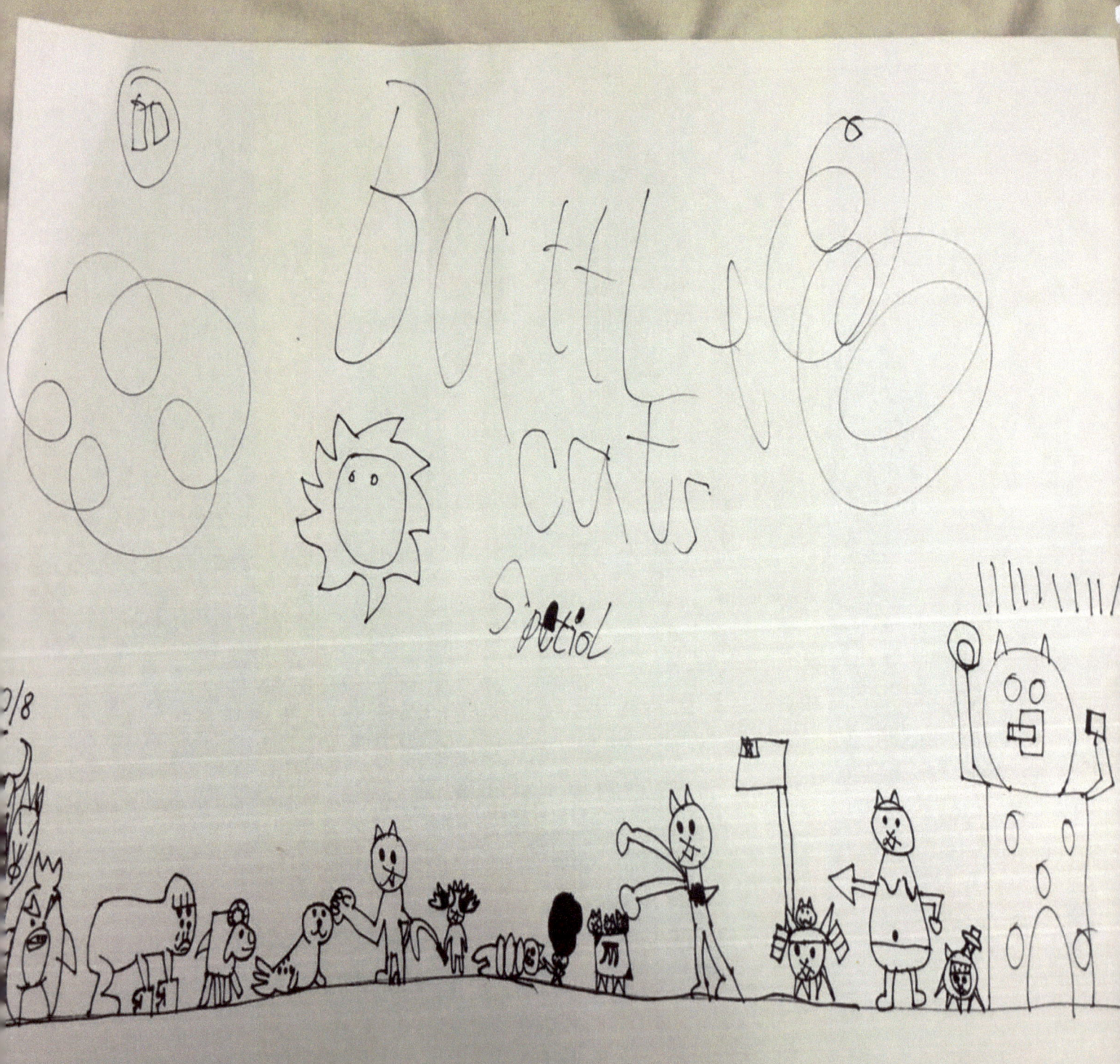

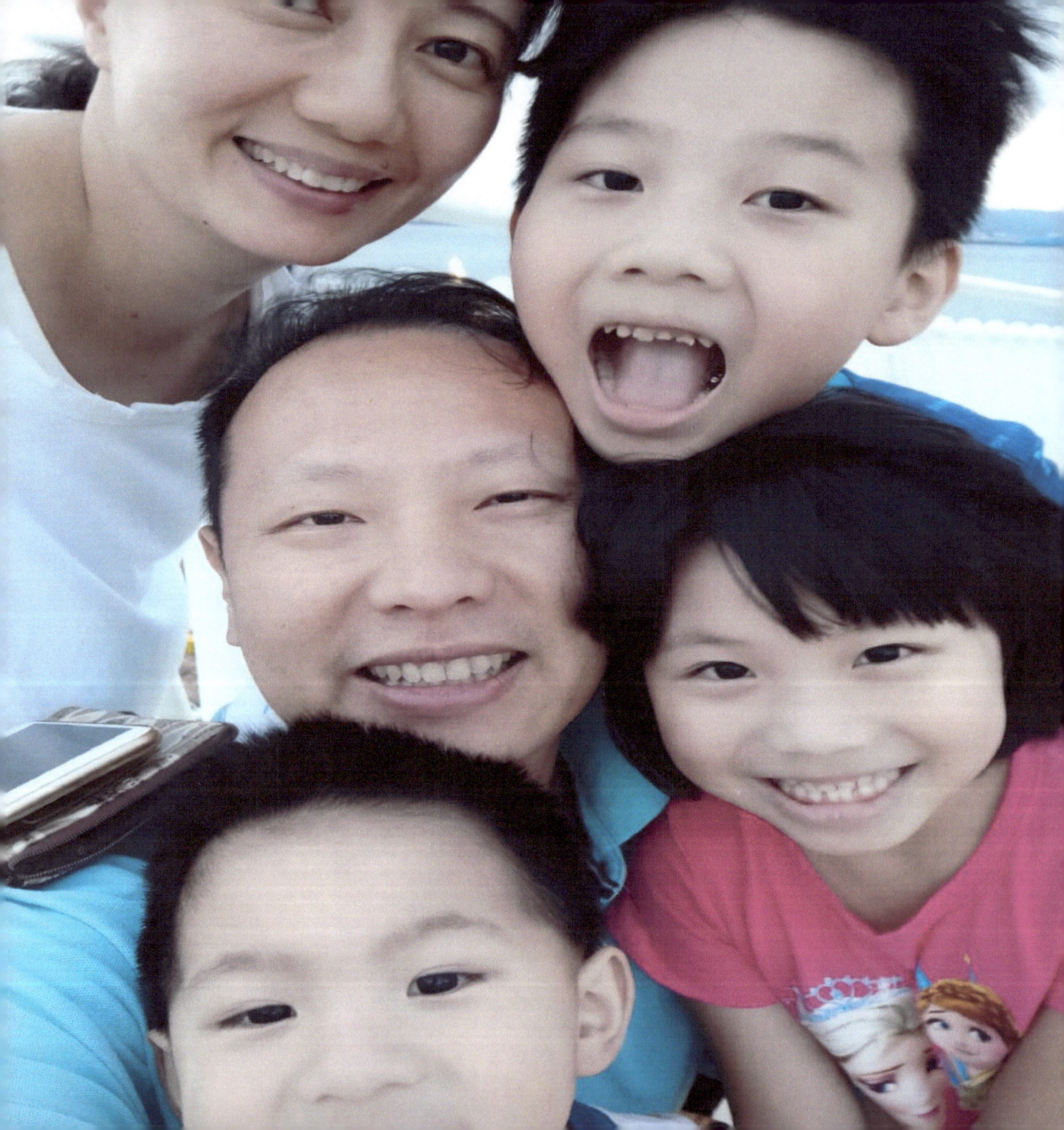

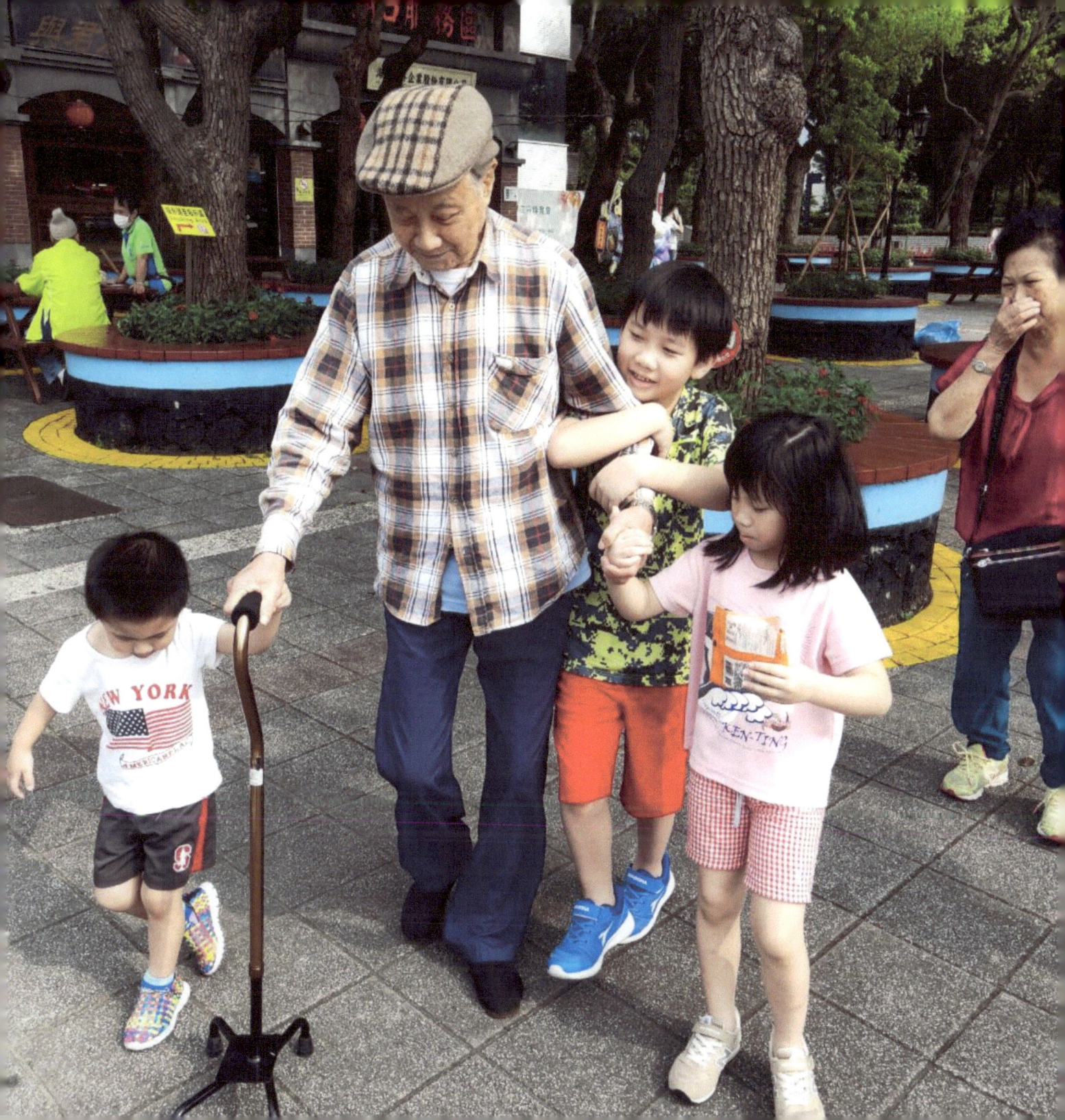

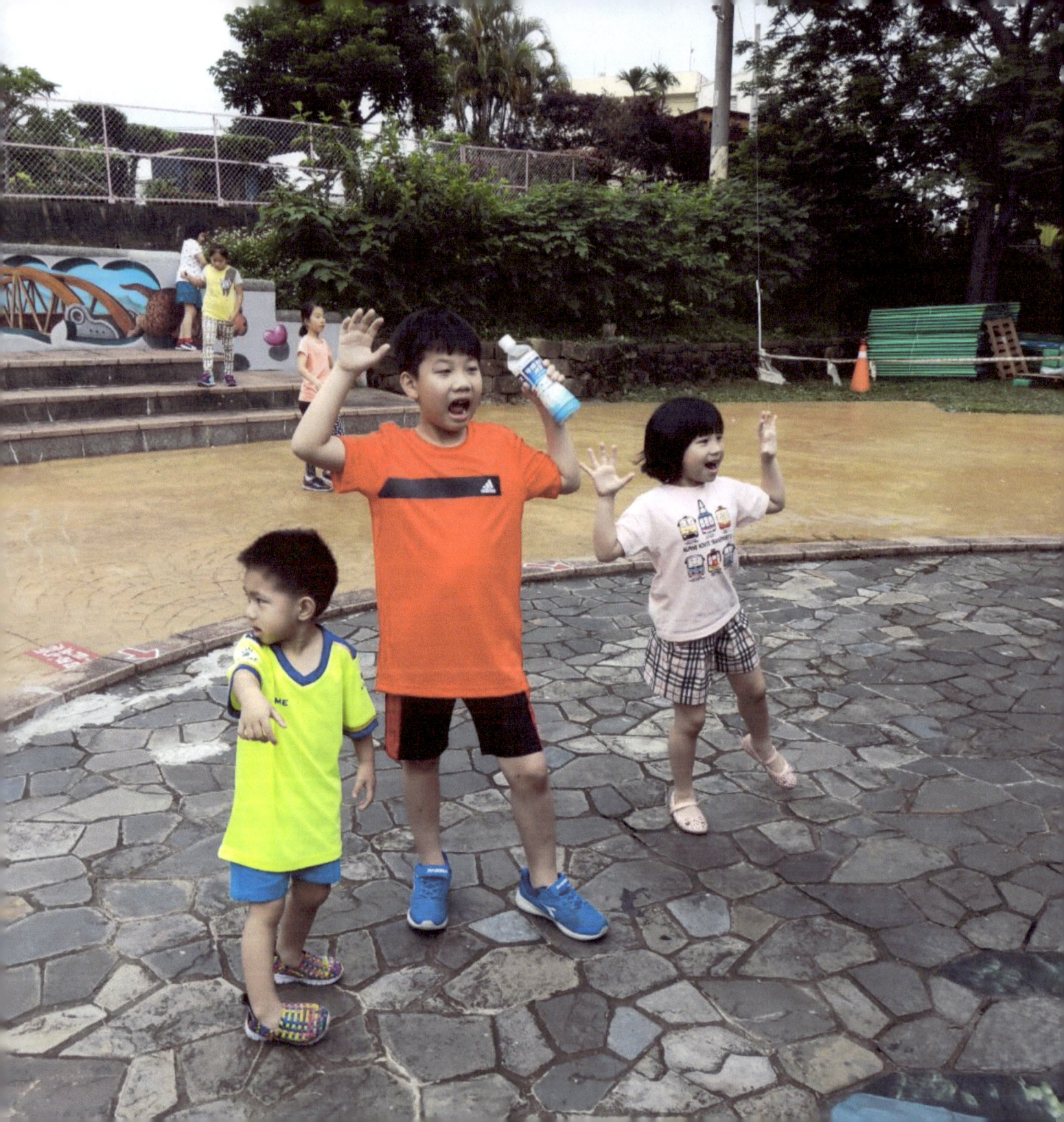

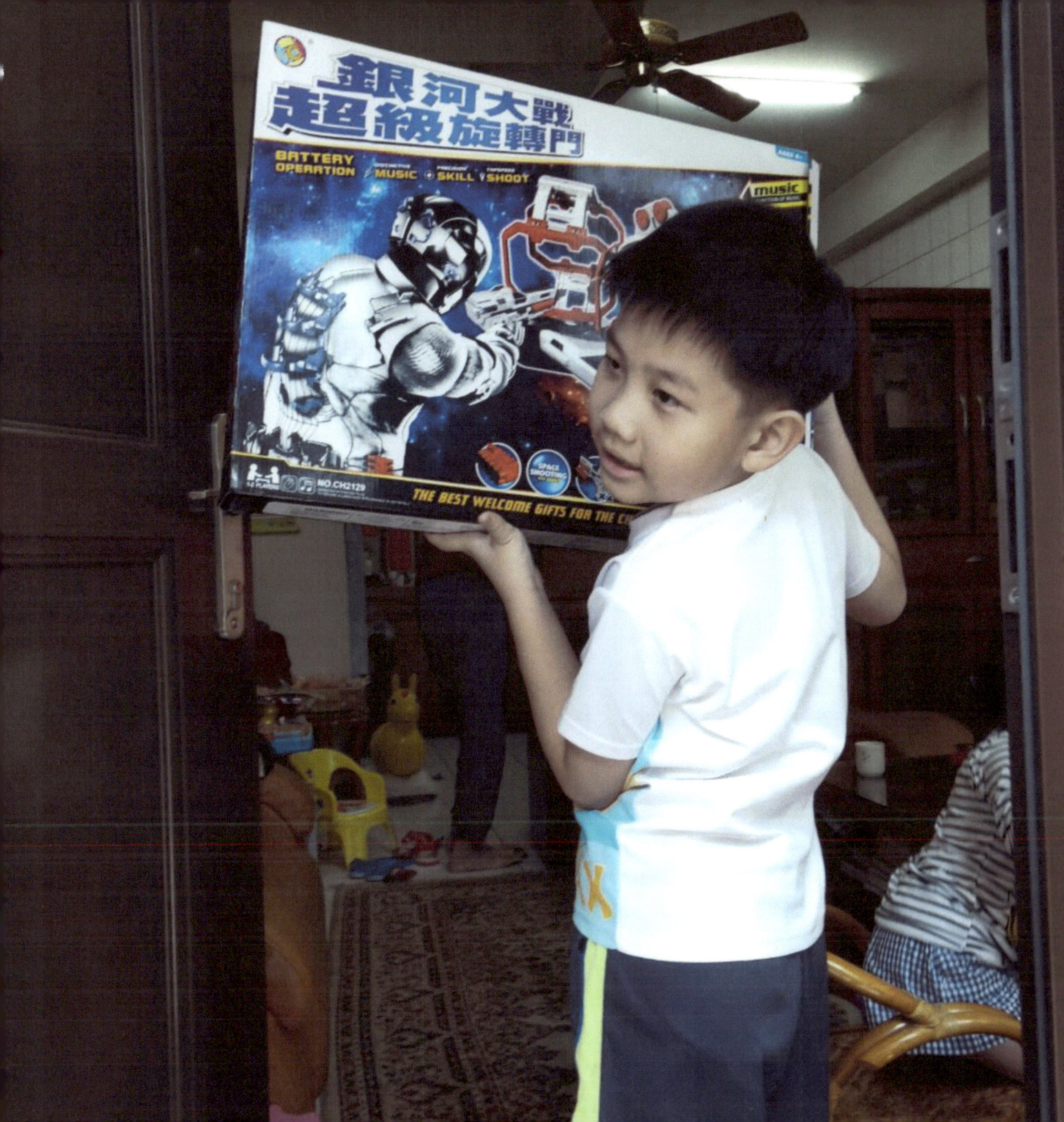

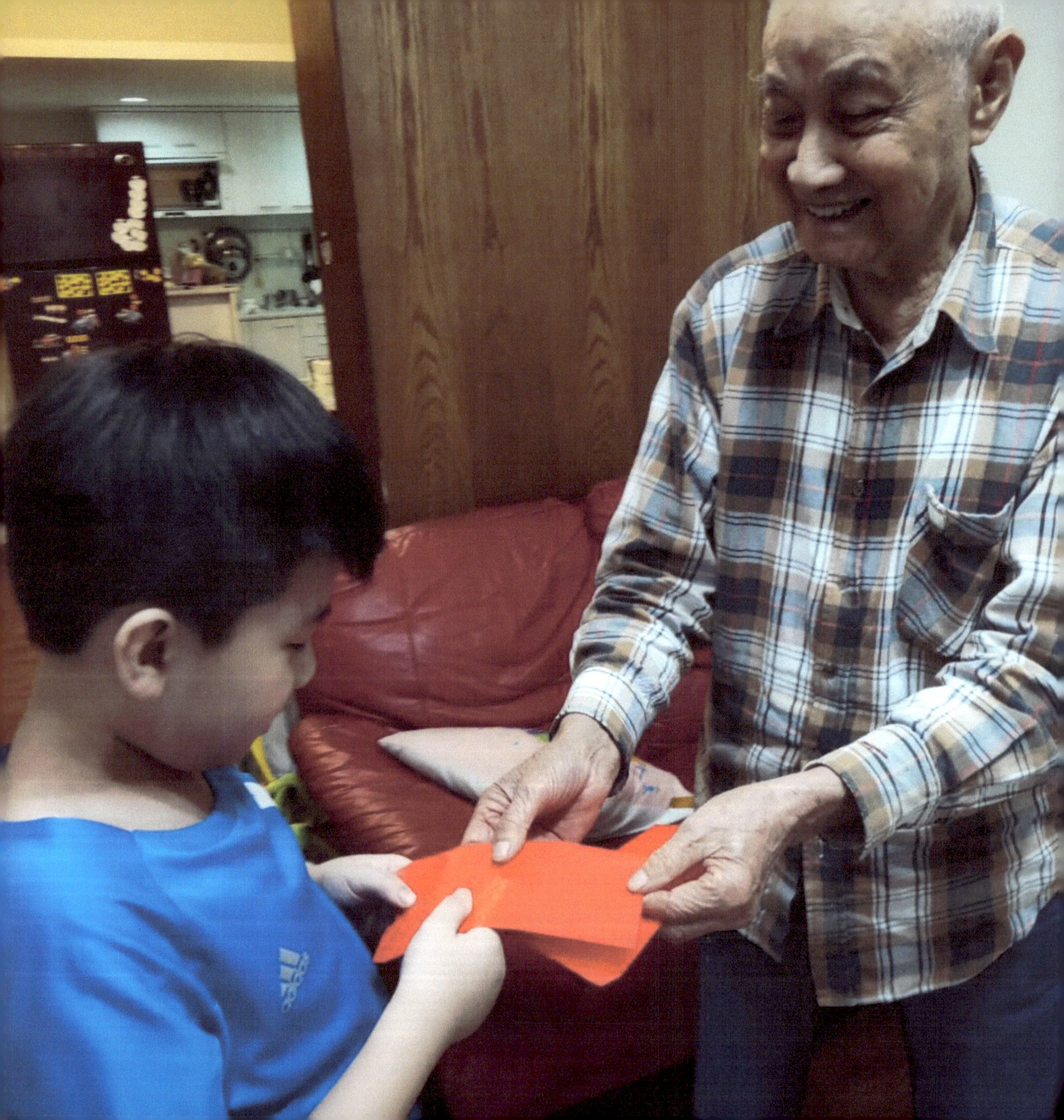

www.ingramcontent.com/pod-product-compliance
Lightning Source LLC
Chambersburg PA
CBHW041308180526
45172CB00003B/1022